HUDSON RIVER SCHOO

WADSWORTH ATHENEUM ✳ A BOO

Pomegranate

SAN FRANCISCO

Pomegranate Communications, Inc.
19018 NE Portal Way, Portland OR 97230
800 227 1428; www.pomegranate.com

Pomegranate Europe Ltd.
Unit 1, Heathcote Business Centre, Hurlbutt Road
Warwick, Warwickshire CV34 6TD, UK
[+44] 0 1926 430111; sales@pomeurope.co.uk

ISBN 978-0-87654-900-1
Pomegranate Catalog No. A827

Pomegranate publishes books of postcards on a wide range of subjects.
Please contact the publisher for more information.

Cover designed by Young Jin Kim
Printed in Korea
25 24 23 22 21 20 19 18 17 16 22 21 20 19 18 17 16 15 14 13

To facilitate detachment of the postcards from this book, fold each card along its perforation line before tearing.

America's first native school of landscape painting emerged between 1825 and 1875, when artists created a distinctive style of landscape painting that all but replaced portraiture as the premier focus of painting in the United States. This group of artists, now known as the Hudson River School, was active in New York City and frequented the Catskill Mountains region, where several built houses along the Hudson River. The scenery of upstate New York—a part of the tourist circuit at this time, but often depicted as a wilderness region by the earliest of these artists—was their initial subject matter. Thomas Cole, the acknowledged founder of the Hudson River School, established a pictorial model reflecting the themes and ideas that he and his patrons espoused. The discovery, exploration, and settlement of the land were central to the enterprise of the American landscape painters. Symbolic images of the American wilderness, depicted as untouched since Creation (and often identified with the figure of a Native American), evoked the Edenic purity of the so-called New World and the hope for a fresh start. As the land was cultivated and the wilderness was settled, artists tried to come to terms with the pros and cons of progress. While industry grew and the country expanded westward, painters depicted the newly settled landscape as a

pastoral setting where human and nature could coexist in a balance of power. South America and the West would later entice other Hudson River School painters, such as Frederic Edwin Church and Albert Bierstadt, who traveled widely in search of more exotic locations to paint.

The Wadsworth Atheneum, located in Hartford, Connecticut, contains one of the most extensive collections of Hudson River School paintings in the world, largely due to the interests of the museum's founder, Daniel Wadsworth (1771–1848). His important collection of romantic American landscapes, most of which were direct commissions from the leading landscape painters of the day, form the core of the Atheneum's great collection. The thirty paintings reproduced in this book of postcards represent the broad range and quality of the Atheneum's collection of Hudson River School paintings.

Elizabeth Mankin Kornhauser
Curator of American Paintings, Sculpture, and Drawings
Wadsworth Atheneum

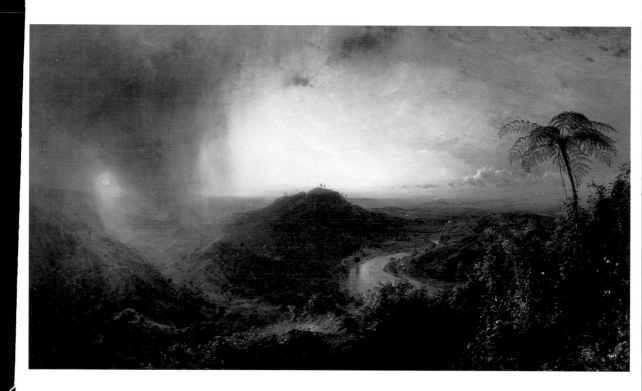

HUDSON RIVER SCHOOL PAINTINGS

Frederic Edwin Church (American, 1826–1900)
Vale of St. Thomas, Jamaica, 1867
Oil on canvas, 48⁵⁄₁₆ x 84⁵⁄₈ in.
Bequest of Elizabeth Hart Jarvis Colt

POMEGRANATE BOX 6099 ROHNERT PARK CA 94927

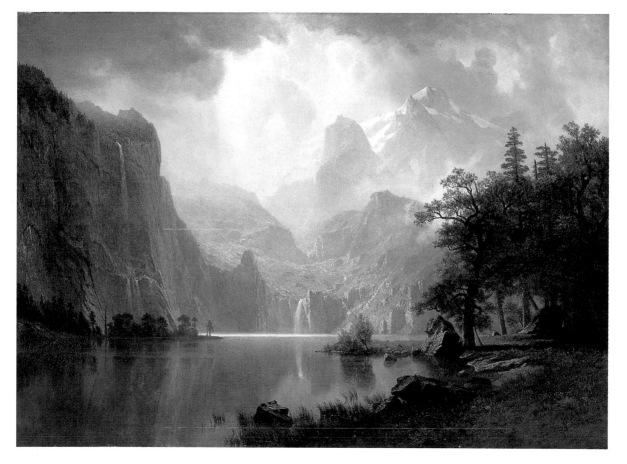

HUDSON RIVER SCHOOL PAINTINGS

Albert Bierstadt (American, 1830–1902)
In the Mountains, 1867
Oil on canvas, 36³⁄₁₆ x 50¼ in.
Gift of John J. Morgan in memory of his mother, Juliet
Pierpont Morgan

POMEGRANATE BOX 6099 ROHNERT PARK CA 94927

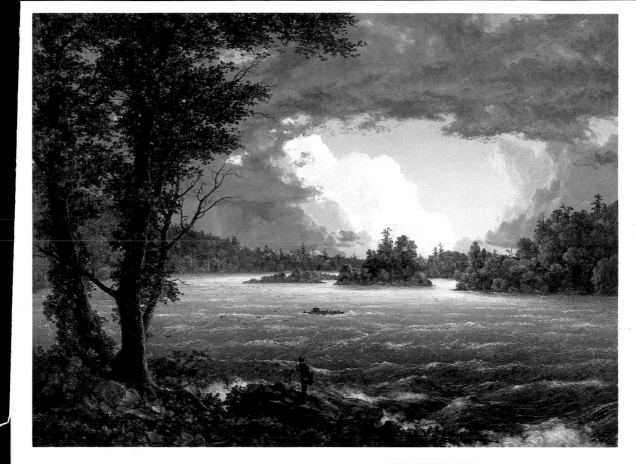

HUDSON RIVER SCHOOL PAINTINGS

Frederic Edwin Church (American, 1826–1900)
Rapids of the Susquehanna, before 1863
Oil on canvas, 22¼ x 30³⁄₁₆ in.

POMEGRANATE BOX 6099 ROHNERT PARK CA 94927

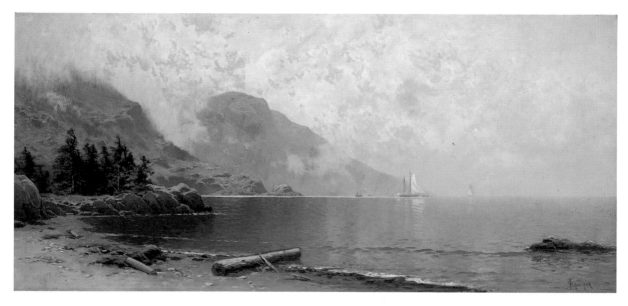

Hudson River School Paintings

Alfred Thompson Bricher (American, 1837–1908)
Maillon's Cove, Grand Manan, Fog Clearing
Oil on canvas, 18⅛ x 39⅛ in.
Bequest of Mrs. Josephine (I. B.) Davis, in memory of her
husband, through Mrs. Frank Belden

Pomegranate Box 6099 Rohnert Park, CA 94927

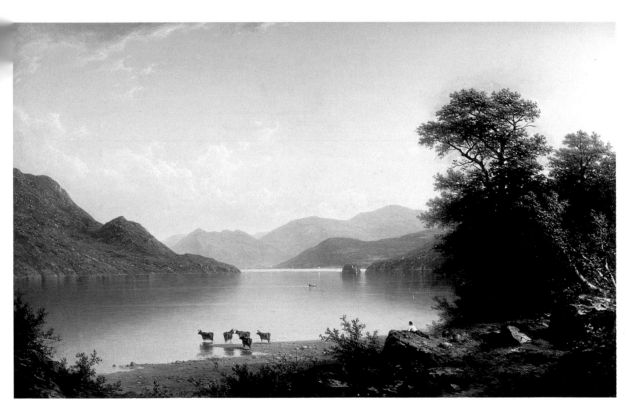

Hudson River School Paintings

John William Casilear (American, 1811–1893)
Lake George, 1860
Oil on canvas, 26¼ x 42¼ in.
Bequest of Mrs. Clara Hinton Gould

Pomegranate Box 6099 Rohnert Park CA 94927

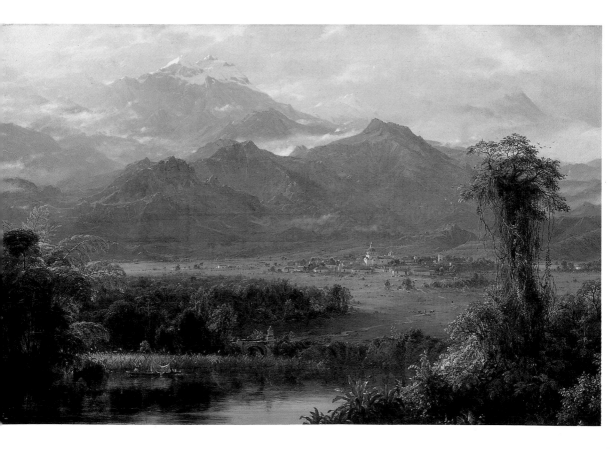

HUDSON RIVER SCHOOL PAINTINGS

Frederic Edwin Church (American, 1826–1900)
Mountains of Ecuador, 1855
Oil on canvas, 24³⁄₁₆ x 36⁵⁄₁₆ in.
Bequest of Mrs. Clara Hinton Gould

POMEGRANATE BOX 6099 ROHNERT PARK CA 94927

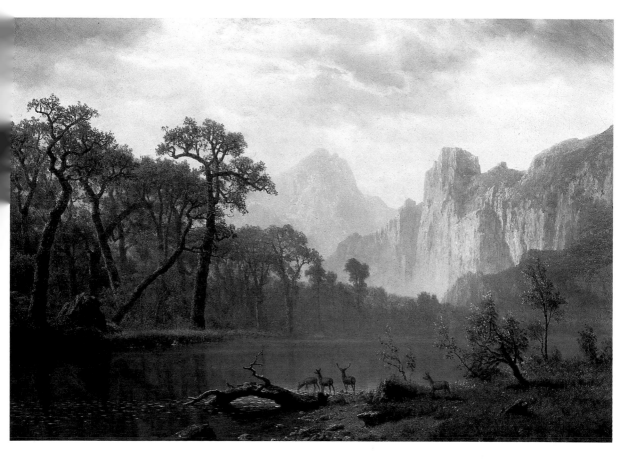

HUDSON RIVER SCHOOL PAINTINGS

Albert Bierstadt (American, 1830–1902)
In the Yosemite Valley, 1866
Oil on canvas, 35⅛ x 50 in.
Bequest of Elizabeth Hart Jarvis Colt

POMEGRANATE BOX 6099 ROHNERT PARK, CA 94927

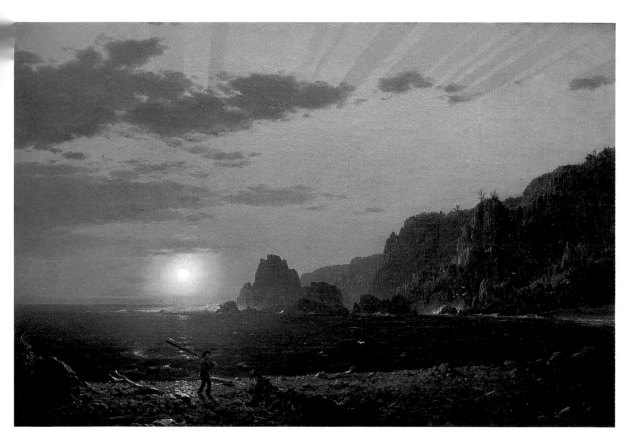

Hudson River School Paintings

Frederic Edwin Church (American, 1826–1900)
Grand Manan Island, Bay of Fundy, 1852, 1852
Oil on canvas, 21³⁄₁₆ x 31⁵⁄₁₆ in.
The Gallery Fund

Pomegranate Box 6099 Rohnert Park, CA 94927

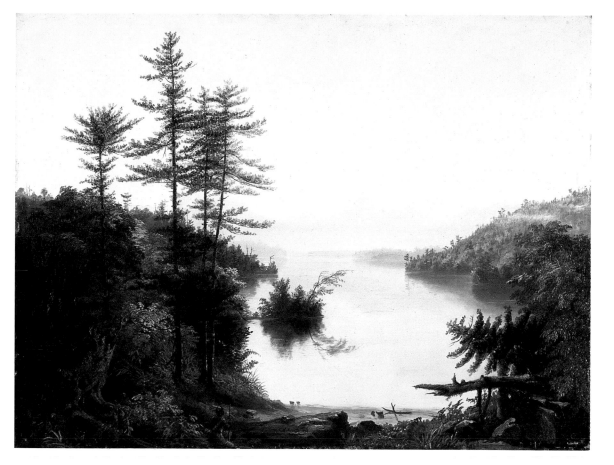

Hudson River School Paintings

Thomas Cole (American, 1801–1848)
View on Lake Winnipiseogee, 1827
Oil on panel, 19¾ x 26⅛ in.
Bequest of Daniel Wadsworth

Pomegranate Box 6099 Rohnert Park CA 94927

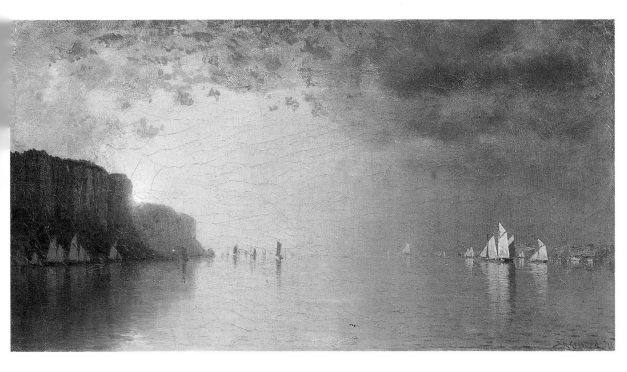

HUDSON RIVER SCHOOL PAINTINGS

Sanford Robinson Gifford (American, 1823–1880)
Sunset on the Hudson, 1876
Oil on canvas, 9 x 15^{15}⁄$_{16}$ in.
The Ella Gallup Sumner and
Mary Catlin Sumner Collection Fund

POMEGRANATE BOX 6099 ROHNERT PARK CA 94927

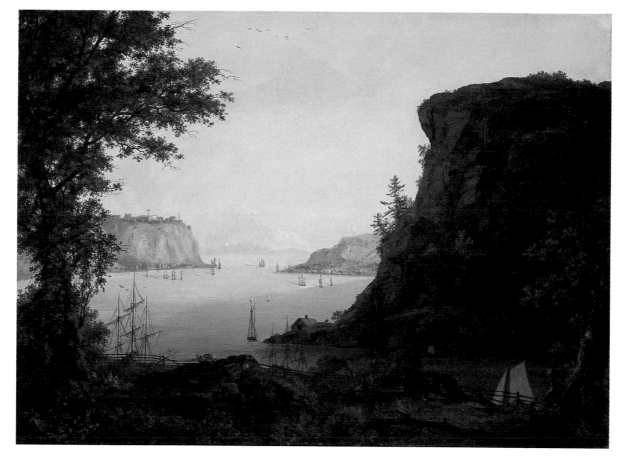

HUDSON RIVER SCHOOL PAINTINGS

Frederic Edwin Church (American, 1826–1900)
View of Quebec, 1846
Oil on canvas, 22³⁄₁₆ x 30³⁄₁₆ in.

POMEGRANATE BOX 6099 ROHNERT PARK CA 94927

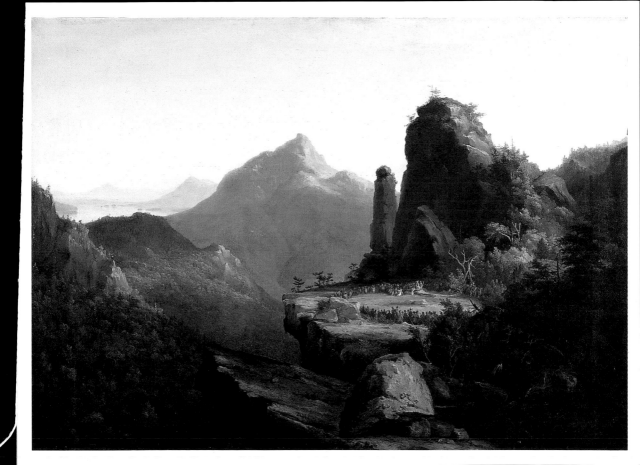

Hudson River School Paintings

Thomas Cole (American, 1801–1848)
Scene from "The Last of the Mohicans," Cora Kneeling at the Feet of Tamenund, 1827
Oil on canvas, 25⅜ x 35¹⁄₁₆ in.
Bequest of Alfred Smith

POMEGRANATE BOX 6099 ROHNERT PARK CA 94927

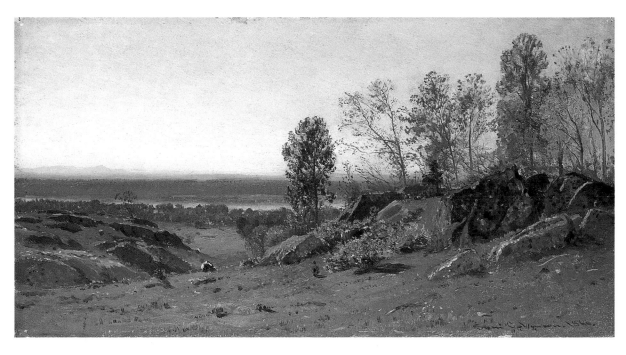

HUDSON RIVER SCHOOL PAINTINGS

Samuel Coleman (American, 1832–1920)
Landscape: Looking across the Country at Irvington-on-Hudson, 1866
Oil on panel, 9¼ x 16¹⁵⁄₁₆ in.
Gift of Mrs. Benjamin Knower

POMEGRANATE BOX 6099 ROHNERT PARK CA 94927

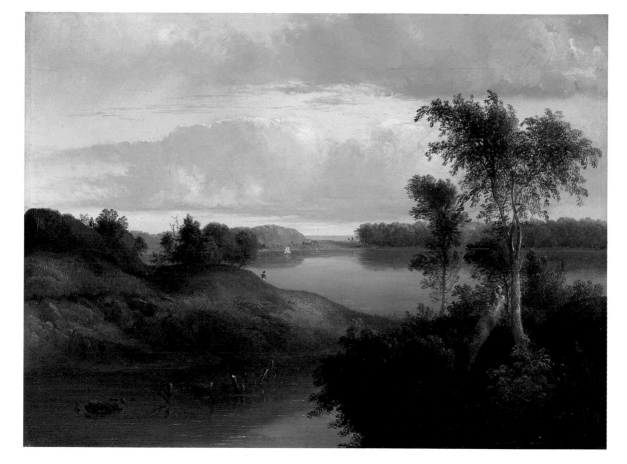

HUDSON RIVER SCHOOL PAINTINGS

Thomas Doughty (American, 1793–1856)
Field and Stream, 1836
Oil on canvas, 17¹⁵⁄₁₆ x 24³⁄₁₆ in.
The Ella Gallup Sumner and
Mary Catlin Sumner Collection Fund

POMEGRANATE BOX 6099 ROHNERT PARK CA 94927

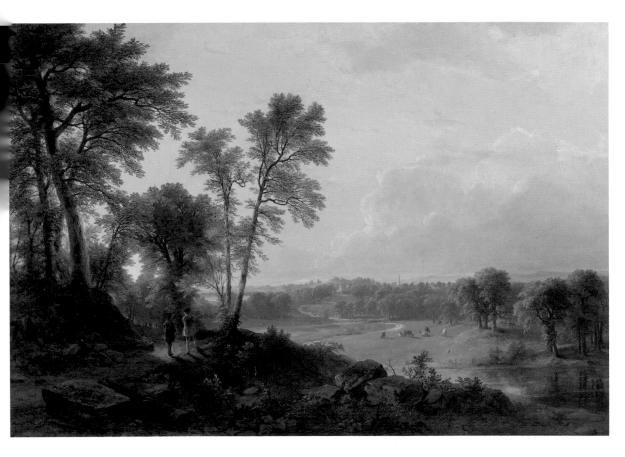

HUDSON RIVER SCHOOL PAINTINGS

Asher B. Durand (American, 1796–1886)
View towards Hudson Valley, 1851
Oil on canvas, 33⅛ x 48⅛ in.
The Ella Gallup Sumner and
Mary Catlin Sumner Collection Fund

POMEGRANATE BOX 6099 ROHNERT PARK, CA 94927

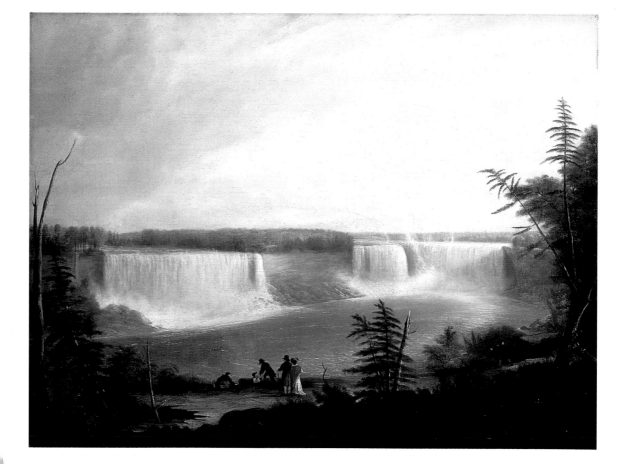

HUDSON RIVER SCHOOL PAINTINGS

Alvan Fisher (American, 1792–1863)
Niagara Falls, 1823
Oil on canvas mounted on wood panel, 23 1/16 x 30 1/8 in.
Bequest of Mrs. Clara Hinton Gould

POMEGRANATE BOX 6099 ROHNERT PARK CA 94927

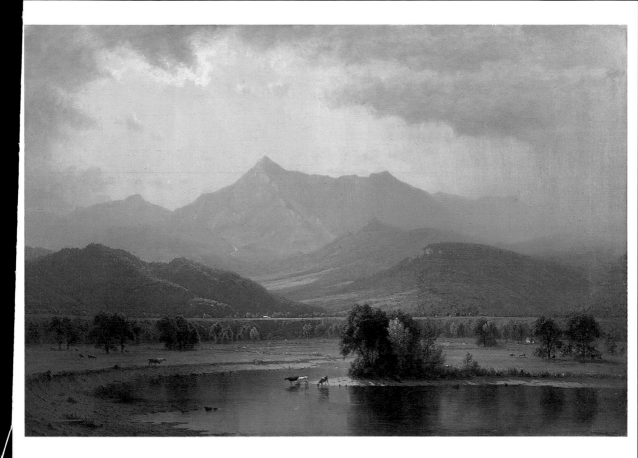

HUDSON RIVER SCHOOL PAINTINGS

Sanford Robinson Gifford (American, 1823–1880)
A Passing Storm in the Adirondacks, 1866
Oil on canvas, 37⅜ x 54⅜ in.
Bequest of Elizabeth Hart Jarvis Colt

POMEGRANATE BOX 6099 ROHNERT PARK CA 94927

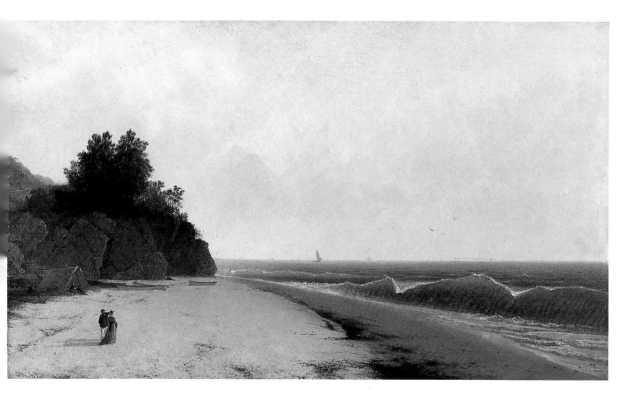

Hudson River School Paintings

John Frederick Kensett (American, 1816–1872)
Coast Scene with Figures (Beverly Shore), 1869
Oil on canvas, 36¼ x 60¼ in.
The Ella Gallup Sumner and
Mary Catlin Sumner Collection Fund

Pomegranate Box 6099 Rohnert Park CA 94927

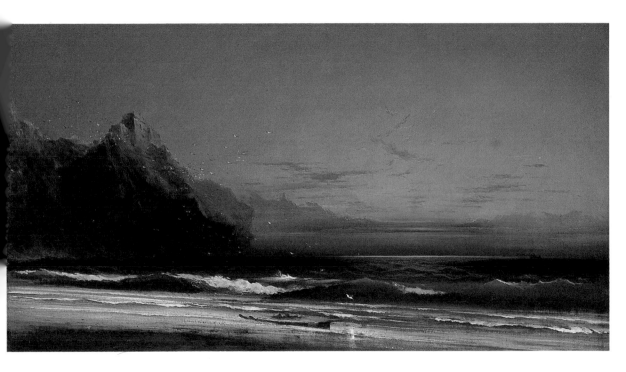

Hudson River School Paintings

James Hamilton (American, 1819–1878)
Evening on the Seashore, 1867
Oil on canvas, 23$\frac{5}{16}$ x 42$\frac{1}{8}$ in.
Bequest of Elizabeth Hart Jarvis Colt

Pomegranate Box 6099 Rohnert Park CA 94927

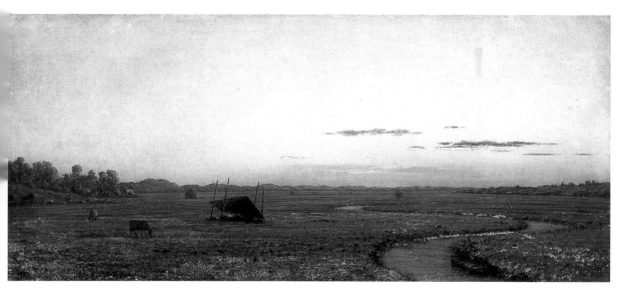

HUDSON RIVER SCHOOL PAINTINGS

Martin Johnson Heade (American, 1819–1904)
Winding River, Sunset, 1863
Oil on canvas, 10³⁄₁₆ x 22³⁄₁₆ in.
The Ella Gallup Sumner and
Mary Catlin Sumner Collection Fund

POMEGRANATE BOX 6099 ROHNERT PARK CA 94927

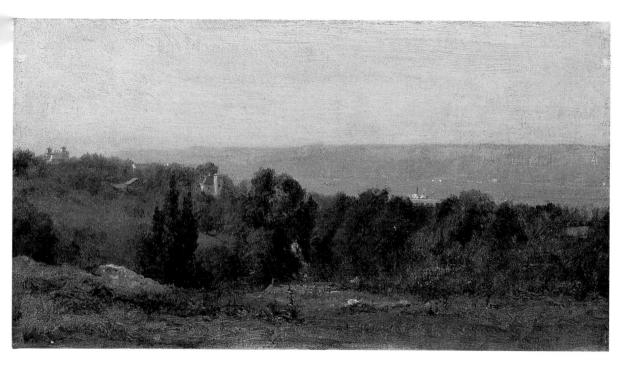

Hudson River School Paintings

George Inness (American, 1825–1894)
Along the Hudson, c. 1875–1880
Oil on canvas, 12¹⁵⁄₁₆ x 12¹⁄₁₆ in.
Gift of Henry E. Schnakenberg

Pomegranate Box 6099 Rohnert Park CA 94927

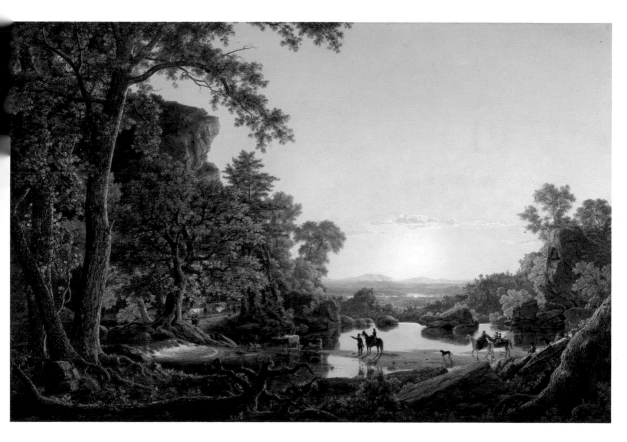

Hudson River School Paintings

Frederic Edwin Church (American, 1826–1900)
Hooker and Company Journeying through the Wilderness in 1636 from Plymouth to Hartford, 1846
Oil on canvas, 40¼ x 60³⁄₁₆ in.
Purchased from the artist before 1850

POMEGRANATE BOX 6099 ROHNERT PARK CA 94927

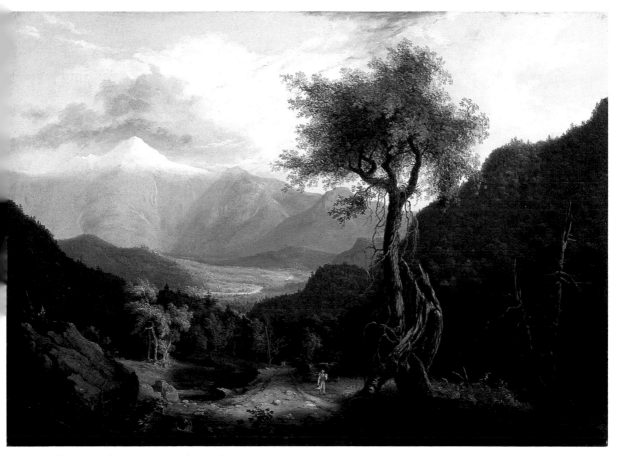

Hudson River School Paintings

Thomas Cole (American, 1801–1848)
View of the White Mountains, 1827
Oil on canvas, 25⅜ x 35³⁄₁₆ in.
Bequest of Daniel Wadsworth

POMEGRANATE BOX 6099 ROHNERT PARK, CA 94927

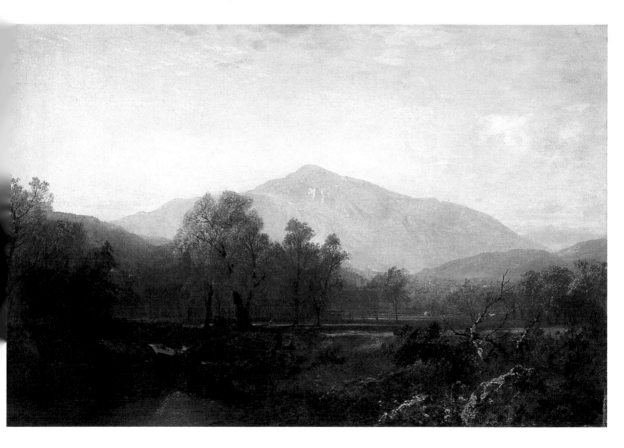

Hudson River School Paintings

John Frederick Kensett (American, 1816–1872)
Mount Washington from the Conway Valley, 1867
Oil on canvas, 24⅛ x 36⅜ in.
Bequest of Elizabeth Hart Jarvis Colt

Pomegranate Box 6099 Rohnert Park CA 94927

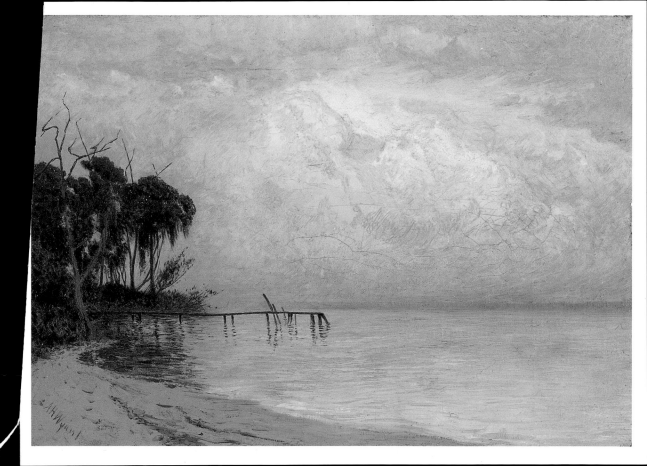

HUDSON RIVER SCHOOL PAINTINGS

Alexander Helwig Wyant (American, 1836–1892)
Florida Sunset, c. 1885–1892
Oil on canvas, 10¹⁄₁₆ x 14 in.
The Gallery Fund

POMEGRANATE BOX 6099 ROHNERT PARK CA 94927

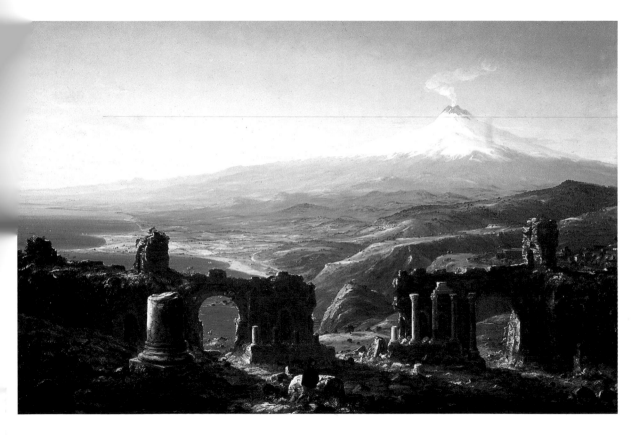

Hudson River School Paintings

Thomas Cole (American, 1801–1848)
Mount Etna from Taormina, 1843
Oil on canvas, 78⅝ x 120⅝ in.
Purchased from the artist by Daniel Wadsworth for the
Wadsworth Atheneum, assisted by Alfred Smith

Pomegranate Box 6099 Rohnert Park CA 94927

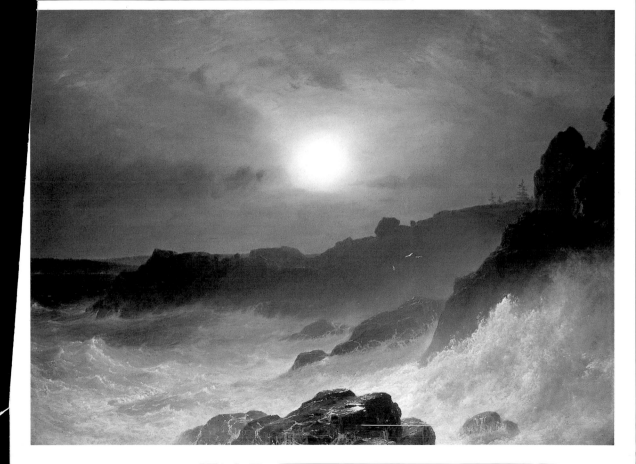

HUDSON RIVER SCHOOL PAINTINGS

Frederick Edwin Church (American, 1826–1900)
Coast Scene, Mount Desert (Sunrise off the Maine Coast), 1863
Oil on canvas, 36⅛ x 48 in.
Bequest of Mrs. Clara Hinton Gould

POMEGRANATE BOX 6099 ROHNERT PARK CA 94927

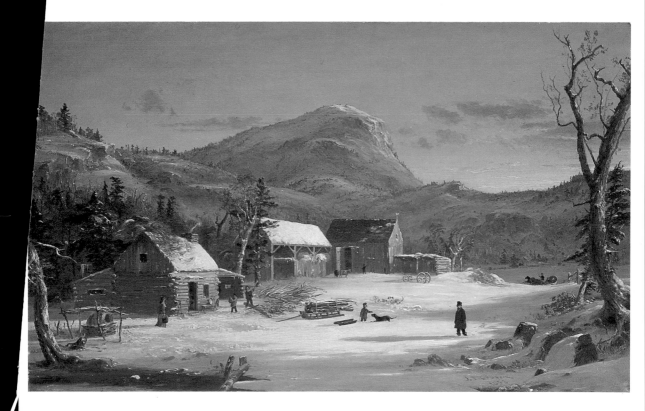

HUDSON RIVER SCHOOL PAINTINGS

Jasper Francis Cropsey (American, 1823–1900)
Winter Scene—Ramapo Valley, 1853
Oil on canvas, 22$\frac{1}{16}$ x 36$\frac{1}{16}$ in.
Gift of George H. Clark through Charles Hopkins Clark

POMEGRANATE BOX 6099 ROHNERT PARK, CA 94927

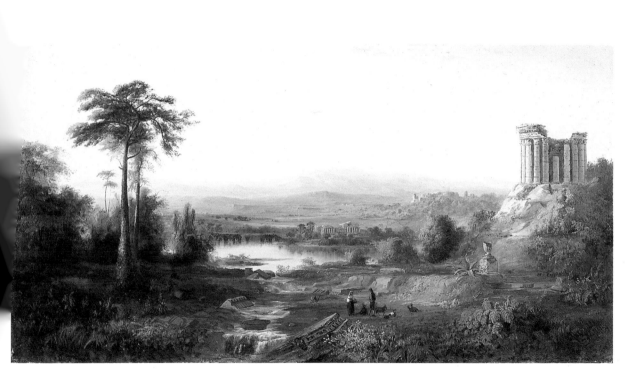

Hudson River School Paintings

Robert Scott Duncanson (American, 1821–1872)
Recollections of Italy, 1864
Oil on canvas, 20½ x 39 in.
The Dorothy Clark Archibald and Thomas L. Archibald Fund

Pomegranate Box 6099 Rohnert Park CA 94927

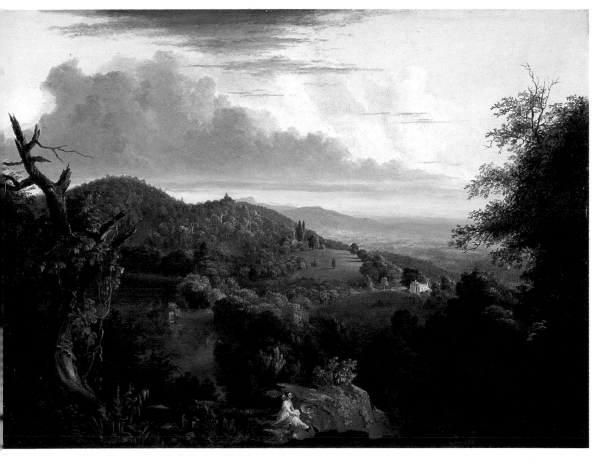

HUDSON RIVER SCHOOL PAINTINGS

Thomas Cole (American, 1801–1848)
View of Monte Video, the Seat of Daniel Wadsworth, Esq., 1828
Oil on panel, 19¾ x 26¹⁄₁₆ in.
Bequest of Daniel Wadsworth

POMEGRANATE BOX 6099 ROHNERT PARK CA 94927